CHATHAM

HISTORY TOUR

Dedicated to Isla, my granddaughter.

First published 2017

Amberley Publishing
The Hill, Stroud,
Gloucestershire, GL5 4EP
www.amberley-books.com

Copyright © Philip MacDougall, 2017
Map contains Ordnance Survey data
© Crown copyright and database right
[2017]

The right of Philip MacDougall to be
identified as the Author of this work
has been asserted in accordance with
the Copyrights, Designs and Patents
Act 1988.

ISBN 978 1 4456 6660 0 (print)
ISBN 978 1 4456 6661 7 (ebook)

British Library Cataloguing in
Publication Data.
A catalogue record for this book is
available from the British Library.

Origination by Amberley Publishing.
Printed in Great Britain.

INTRODUCTION

With a naval dockyard established at the time of Elizabeth I, military fortifications from the period of the Hanoverian monarchs and two shopping centres that are unquestionably Victorian in origin, Chatham is very much a town of historical contrasts. In dividing this book into three separate walks, these contrasts are fully recognised.

The first walk leads, quite unusually, through the middle of the main shopping centre – the High Street. While giving an air of modernity, most of the buildings are of clear Victorian vintage and have stories that reflect the harshness of a military town of the nineteenth century. Look above the ground-floor alterations and a clear idea can be gained of just how Chatham appeared some 150 years ago.

The second walk is very different, taking in the length of Dock Road and the adjoining stretch of river. This was the martial heart of Chatham, a Georgian military-industrial complex that has Fort Amherst at one end and an incredibly important naval dockyard at the other with a swathe of other military buildings that once stood betwixt the two.

Finally, the third walk is a return to the age of Queen Victoria by way of a perambulation through the great extension that tripled the size of the original dockyard. It is a much-neglected part of Chatham's history, with emphasis normally upon the Historic Dockyard that lies just beyond Main Gate rather than this other dockyard that was entered via Pembroke Gate. Here some of the facilities that existed in and around St Mary's Island and built, in part, by hundreds of convicts whose prison stood where university buildings now thrive can still be found.

With each walk taking no longer than an hour, they can easily be taken at leisure with a venue for tea and cake easily to be found at the beginning and end of all of these walks – unless, of course, opting for a midnight ramble!

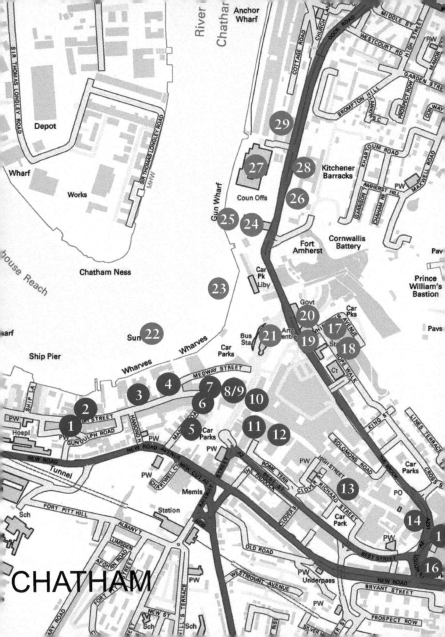

CHATHAM

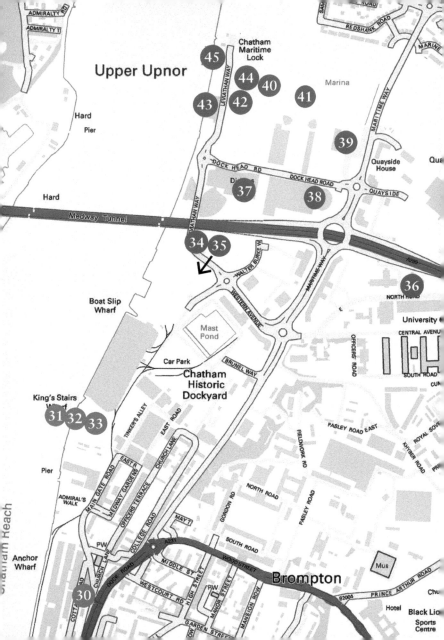

KEY

High Street

1. St Bartholomew's Chapel
2. The Hospital of Sir John Hawkins
3. Empire Theatre
4. Sun Hotel
5. Manor Road
6. Theatre Royal
7. Palace of Varieties
8. Edward Bates'
9. Inside Edward Bates'
10. Sir John Hawkins Flyover
11. Railway Street
12. Central Hall
13. High Street (East End)
14. Brook–High Street Intersection
15. Cannon Cinema
16. Luton Arches

To The Dockyard

17. Royal Sailors' Home
18. The Town Hall
19. Trams and Buses
20. Royal Marine School
21. The Paddock

The Victorian Dockyard

HIGH STREET

This first walk begins at a point in the High Street where Rochester ends and Chatham begins. Sometimes referred to as Chatham Intra, Charles Dickens once wrote of the border between the two, 'if anybody knows to a nicety where Rochester ends and Chatham begins is more than I do'. Fortunately, nowadays, a street sign usefully answers this conundrum.

1. ST BARTHOLOMEW'S CHAPEL

Marking the entrance into Chatham from Rochester is St Bartholomew's Hospital Chapel. A medieval building in origin, but heavily restored by Sir Gilbert Scott during the nineteenth century, it was part of the original St Bartholomew's Hospital that had been established in 1078 for those suffering from leprosy. Its current state does little to enhance Chatham as a centre for tourism while its future is currently uncertain.

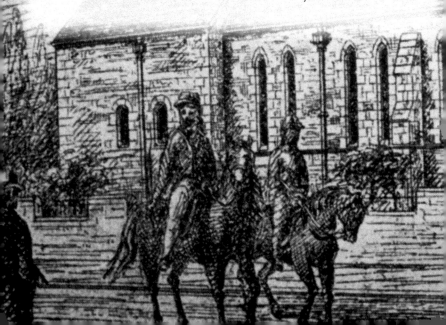

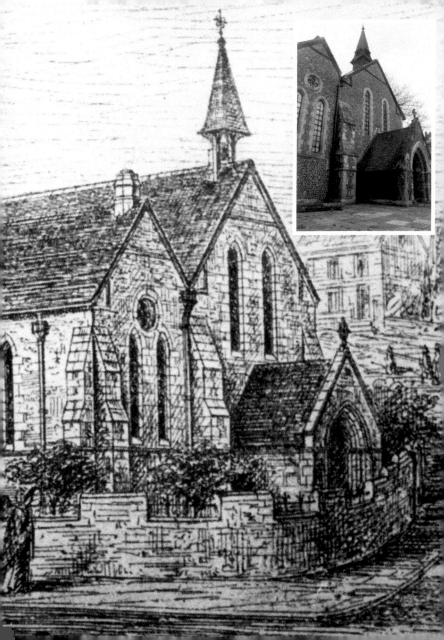

2. THE HOSPITAL OF SIR JOHN HAWKINS

On the opposite side of the High Street to St Bartholomew's Chapel is the Hospital of Sir John Hawkins, an almshouse charity catering for the needy or disabled who have served the navy either at sea or in the dockyards. Established by Sir John Hawkins, Treasurer of the Navy during the reign of Elizabeth I, the present building dates to 1789 and consists of eight flats that were completely renovated in 2008. Hawkins also put in place the Chatham Chest, a second charity for the relief of sick and injured seamen, with the Chest at one time kept in the dockyard at Chatham, and out of which monetary payments were made to those in need.

3. EMPIRE THEATRE

The domed building is the Empire of Varieties, which was both a cinema and music hall. Nowadays Anchorage House, the Medway County Court, occupies this same site. All that survives of the Empire is a cut-down part of the original boundary wall. Other buildings that once occupied the High Street in this area are the Empire Oyster Bar (No. 69), S. E. Wills, a photographer (No. 67), M. Brimstead, florists (No. 65) and Nunns, a clothes shop (No. 63). A similarly eclectic collection of shops can still be found in this part of the High Street.

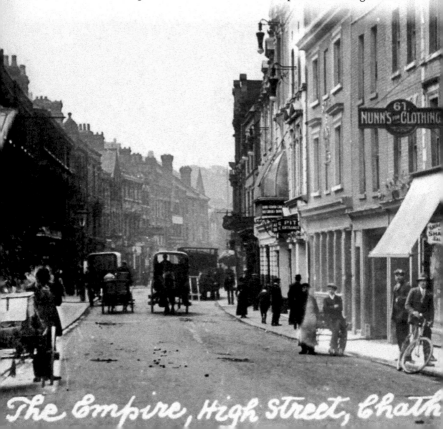

The Empire, High Street, Chath...

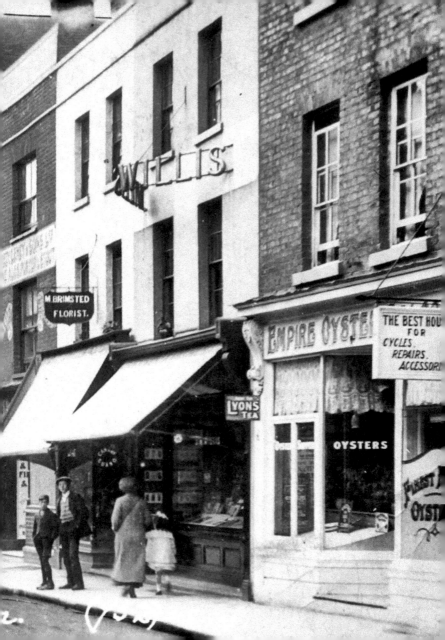

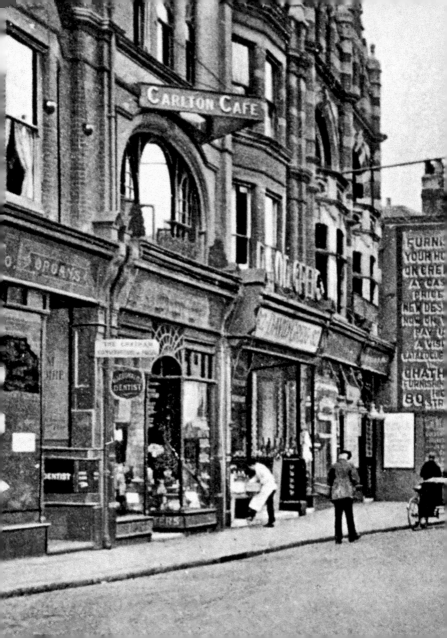

4. SUN HOTEL

Situated at the east end of Chatham High Street, the Sun Hotel (No. 85 High Street) was once the town's leading hotel, described in the 1920s as a 'first class family, commercial, naval and military hotel' that had garaging for cars and, in catering for the prejudices of the time, an 'entirely English staff'. The same site today, on the corner of Medway Street, houses a building that dates to the 1980s.

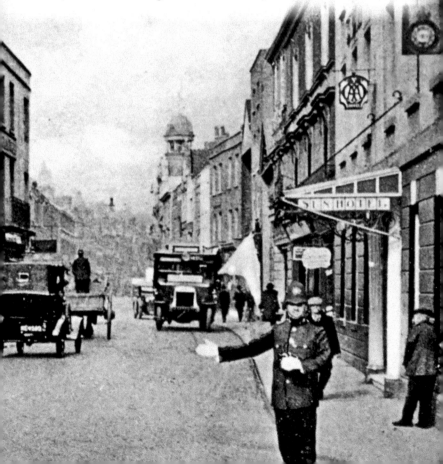

5. MANOR ROAD

Originally the head office of the Chatham Reliance Permanent Building Society, this property is in Manor Road. This picture was taken shortly after completion of the building in 1933. In more recent years, the Chatham Reliance amalgamated with the Kent Reliance Building Society, a fact that explains why the year of establishment differs in the two photographs. In the earlier picture, the year 1898 is given, this being the date when the former mayor of Chatham, H. Paine, helped found the society. However, with the building having fallen into the hands of the Kent Reliance, a society with the earlier founding date of 1888, the establishment year was duly changed (*see* inset). The building is of the mock-Georgian style and was designed to allow for the possible addition of an upper floor. It was constructed at a cost of £5,000.

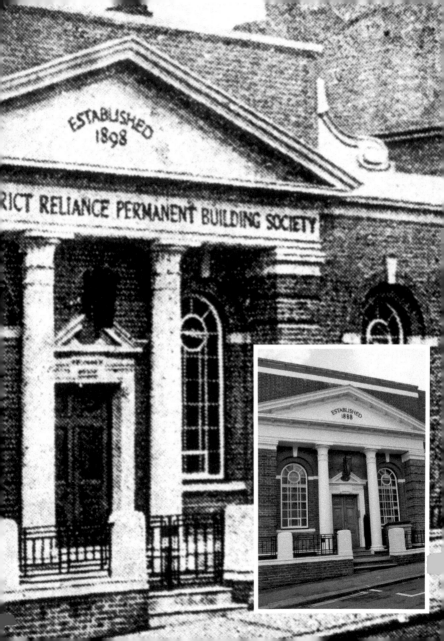

ESTABLISHED 1898

RICT RELIANCE PERMANENT BUILDING SOCIETY

ESTABLISHED 1888

6. THEATRE ROYAL

Once the top-end of entertainment in Chatham, the Theatre Royal, which could seat 3,000, was built in 1899 and continued to put on performances until the mid-1950s when it was converted into shopping space. Briefly, during the early years of the Second World War when it was putting on a series of more risqué performances, the Theatre Royal was known as the Royal Hippodrome.

This is a magnificent building, and at one stage was on the verge

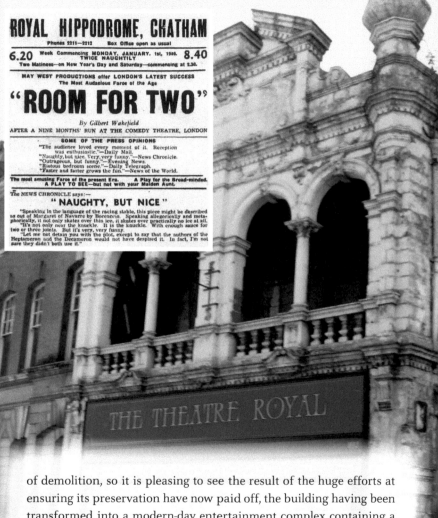

ROYAL HIPPODROME, CHATHAM

Phones 2211—2212 Box Office open as usual

6.20 Week Commencing MONDAY, JANUARY, 1st, 1946. **8.40**
TWICE NAUGHTILY
Two Matinees—on New Year's Day and Saturday—commencing at 2.30.

MAY WEST PRODUCTIONS offer LONDON'S LATEST SUCCESS
The Most Audacious Farce of the Age

"ROOM FOR TWO"

By Gilbert Wakefield
AFTER A NINE MONTHS' RUN AT THE COMEDY THEATRE, LONDON

SOME OF THE PRESS OPINIONS

"The audience loved every moment of it. Reception
was enthusiastic."—Daily Mail.
"Naughty, but nice. Very, very funny."—News Chronicle.
"Outrageous, but funny."—Evening News.
"Riotous bedroom scene."—Daily Telegraph.
"Faster and faster grows the fun."—News of the World.

The most amusing Farce of the present Era. A Play for the Broad-minded.
A PLAY TO SEE—but not with your Maiden Aunt.

The NEWS CHRONICLE says:—

" NAUGHTY, BUT NICE "

"Speaking in the language of the racing stable, this piece might be described
as out of Margaret of Navarre by Borenccio. Speaking allegorically and meta-
phorically, it not only skates over thin ice, it skates over practically no ice at all.
"It's not only near the knuckle. It is the knuckle. With enough sauce for
two or three joints. But it's very, very funny.
"Let me not detain you with the plot, except to say that the authors of the
Heptameron and the Decameron would not have despised it. In fact, I'm not
sure they didn't both use it."

THE THEATRE ROYAL

of demolition, so it is pleasing to see the result of the huge efforts at ensuring its preservation have now paid off, the building having been transformed into a modern-day entertainment complex containing a restaurant, bars and a café. Given that the west end of the High Street had, at one time, a strong Victorian character, it would have been most unfortunate if a building of such merit had been completely sacrificed to the needs of modernity.

7. PALACE OF VARIETIES

Just opposite the Theatre Royal stood the Palace of Varieties, a music hall that succumbed to a serious fire in March 1934. Both this and the Theatre Royal were built by the Barnards, a family long associated with entertainment in Chatham. 'Old Dan' Barnard, the senior member of the family, first entered the entertainment business in Chatham when he turned a rather seedy Granby Coffee Tavern into a music hall back in the 1850s.

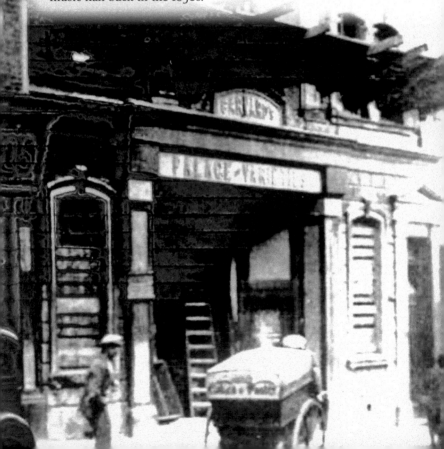

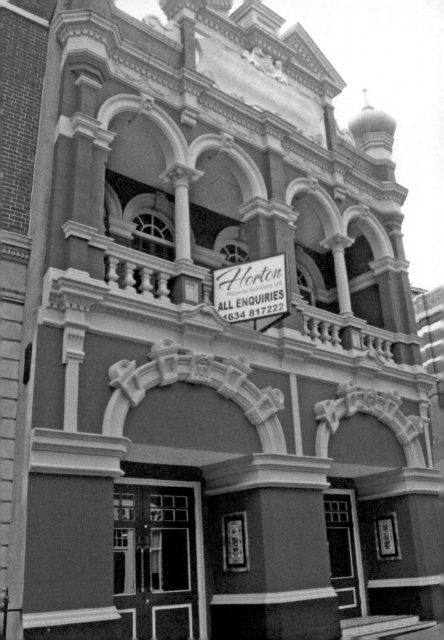

Horton
Property Solutions Ltd.
ALL ENQUIRIES
1634 817222

8. EDWARD BATES'

Edward Bates was a draper that was also located at the west end of the High Street (No. 94–6) at a time when this was a lively and fashionable area. By the 1960s, Edward Bates had diversified into furnishing, fashion and children's wear. Today it is the location of Spoon World Buffet, an Asian and British restaurant.

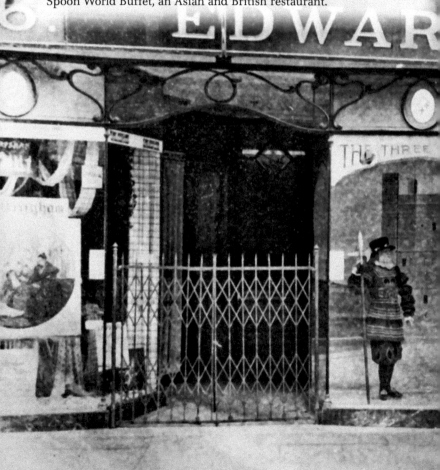

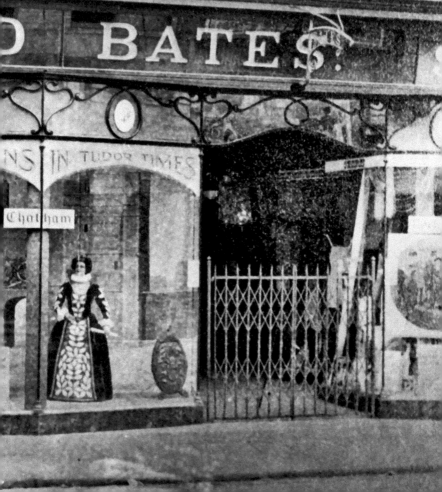

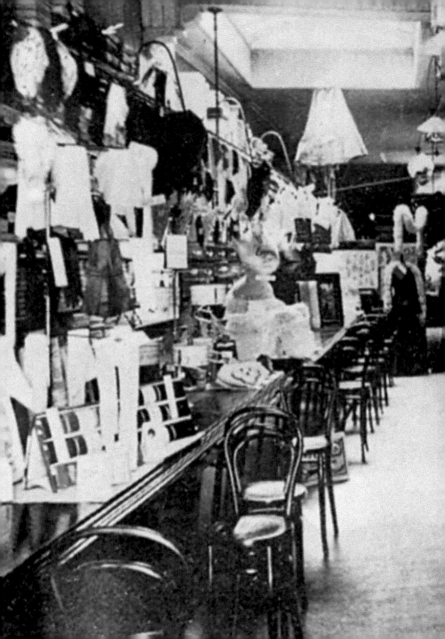

9. INSIDE EDWARD BATES'

Chatham, in having lost its major employer, the naval dockyard, has gradually shifted its economic centre of gravity towards the accumulation of retail outlets. The High Street, supported by numerous corner shops, was once the full extent of the experience. The Pentagon proved the first in-road to the new-style shopping experience followed by the emergence of several expansive supermarkets. However, Edward Bates' offered a somewhat more personal service, with staff always on hand to demonstrate the quality of the fabric or offer pertinent but respectful suggestions.

10. SIR JOHN HAWKINS FLYOVER

The dream, as represented by the artist's impression of what supposedly was to be, was that the Sir John Hawkins flyover, once completed, would actually enhance the west end of the High Street. Planned in the mid-1980s, and constructed as part of the new ring road, it brought not prosperity but decline to an area that had already been suffering since the opening of the Pentagon some twenty years earlier. Even those shops that had stalwartly remained now found themselves under threat as fewer and fewer shoppers chose to go outside the concrete collar that now surrounded the town. In July 2009, the flyover was demolished with a low-level road replacing the flyover and this part of the High Street still remains effectively cut off from the rest of the town.

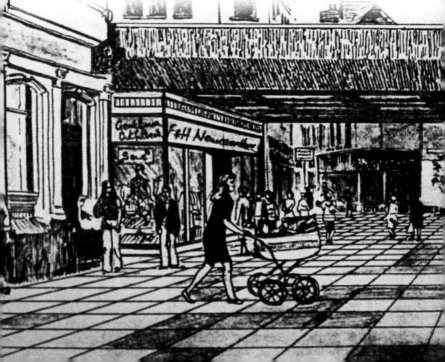

11. RAILWAY STREET

This view along Railway Street through to Military Road was taken shortly before the Second World War. There have been the numerous changes, of which the most recent is the Waterside bus complex. Mountbatten House now makes it virtually impossible to see the town hall while the raised road system saw the necessity to remove a few more Chatham buildings. The premises of W. E. R. Randall (No. 23 Railway Street) is clearly visible, a long-established company that merged with J. D. Walter & Sons in 1976, becoming Walter & Randall.

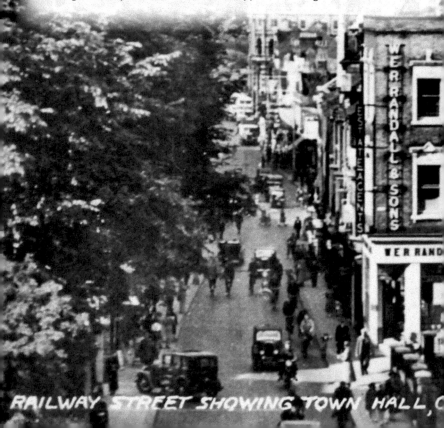

RAILWAY STREET SHOWING TOWN HALL, C

12. CENTRAL HALL

First opened in March 1908 as a Wesleyan Mission and with a remit to provide entertainment in surroundings free of alcohol, the Wesleyan Central Hall was acquired by Chatham Borough Council during the late 1960s. It now serves as a popular local theatre that has staged everything from pop concerts and ballet through to the traditional Christmas pantomime.

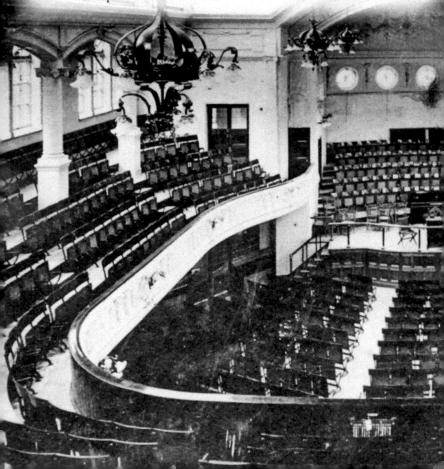

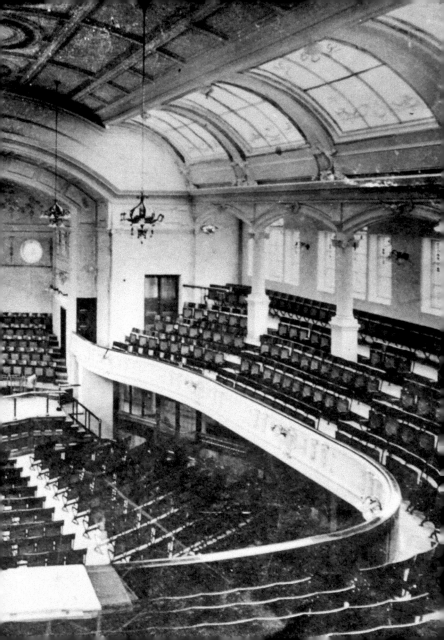

13. HIGH STREET (EAST END)

In this early picture, midway along the right-hand side, can be seen a sign that declares the way 'to the Long Bar'. This represents the entrance to the former United Services Pub, which had a bar that stretched, 'wild west fashion', from front to rear. Fights between different branches of the armed services were quite common, with the Military Provost invariably keeping a close eye on the premises.

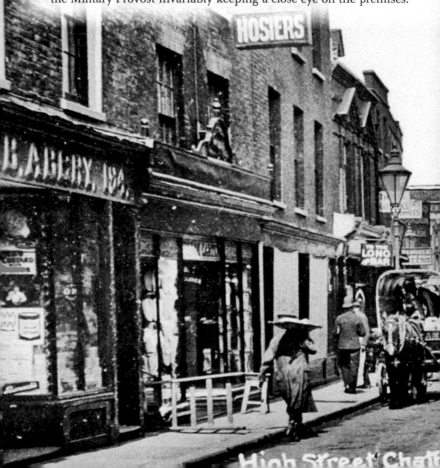

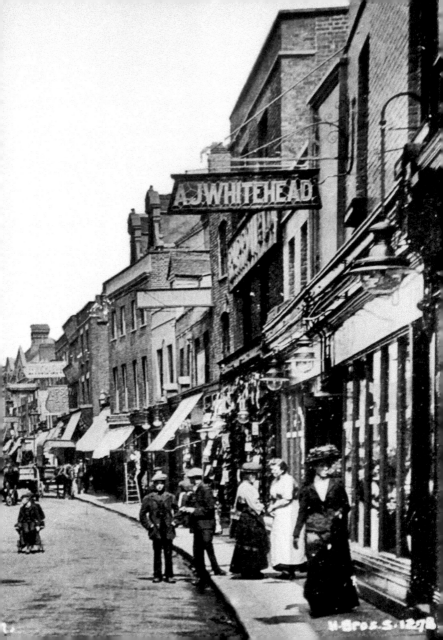

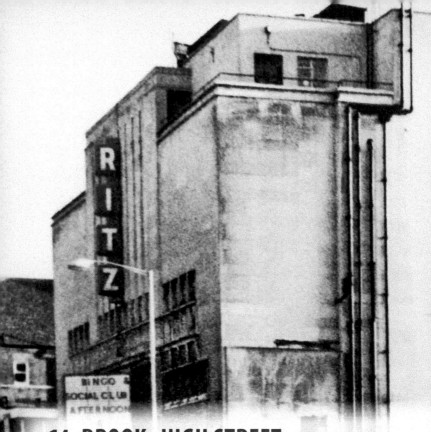

14. BROOK–HIGH STREET INTERSECTION

The area of the High Street where it joins the Brook little resembles how it looked during much of the twentieth century. A particular focal point in this area, at least from 1937 onwards, was the Ritz cinema building. In later years it was to play out its life as a bingo and social club before destruction by fire in September 1998. A reminder of what this area of Chatham might once have looked like is preserved in the architecture of the White Lion, a building in the High Victorian style.

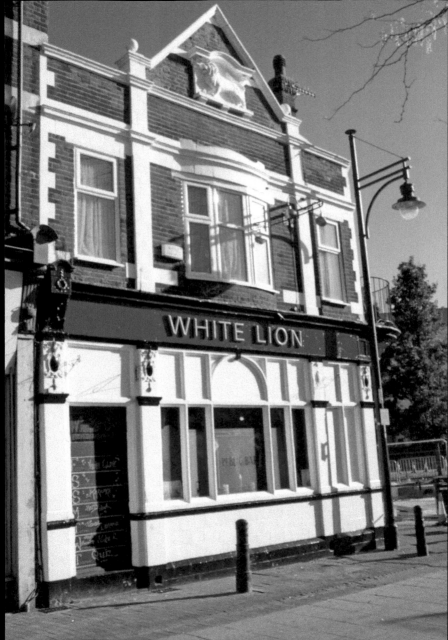

15. CANNON CINEMA

For a brief period in the late 1980s, Chatham's first super cinema, opened as the Super Regent in July 1938, was in the hands of Cannon Cinemas. However, despite its long history, an ageing cinema in this part of Chatham was incapable of competing with the multiplexes and was eventually forced to close, being superseded by an entirely new structure (Pembroke Court) on an extensive site that runs back from the High Street and along much of the length of Upbury Way.

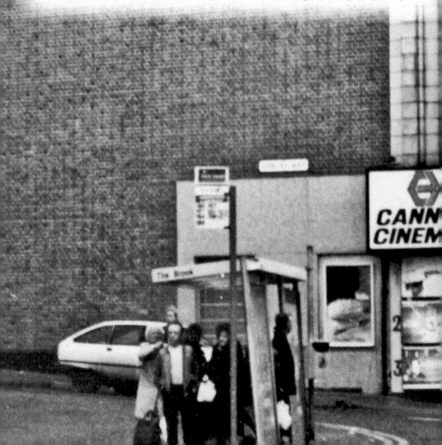

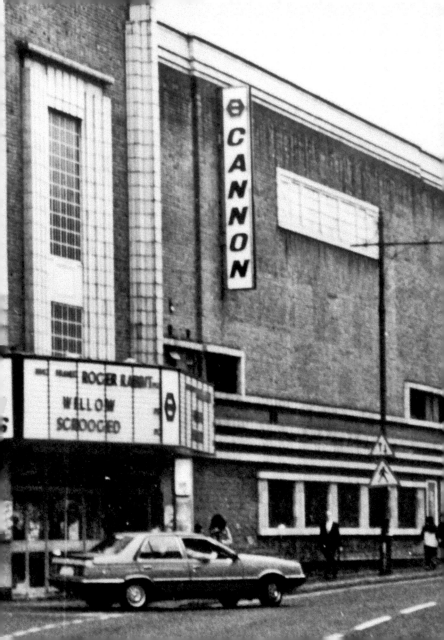

16. LUTON ARCHES

Two views taken from – more or less – an identical position but separated by 100 years. Always busy with traffic, this area is now dominated by cars and a solitary speed camera where once the tramlines of the Chatham & District Light Railway were once embedded. The arches date to 1860 and were originally built for the trains of the London, Chatham & Dover Railway.

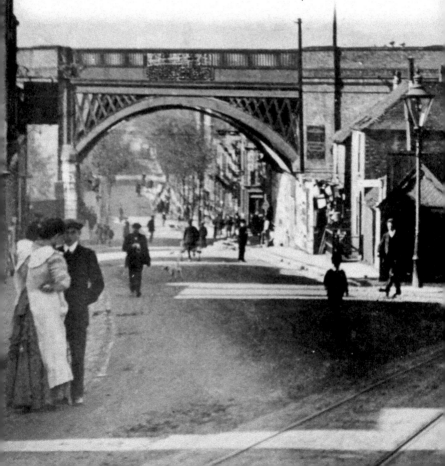

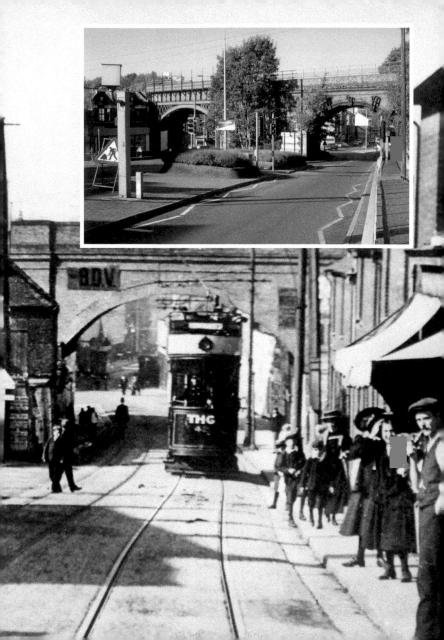

TO THE DOCKYARD

A cluster of buildings and sights around the former Chatham Town Hall (now The Brook Theatre) is the starting point for this walk, with a quick break for sustenance possible in the Fort Amherst Café and Visitor Centre. Part of the walk includes the Historic Dockyard, for which an entry ticket is required.

17. ROYAL SAILORS' HOME

Behind the town hall in Upper Barrier Road once existed the Royal Sailors' Home, a club-type building designed for the entertainment of off-duty sailors in an age when entertainment was limited and Chatham offered a few too many vices. Recently demolished, the Royal Sailors' Home has been replaced by a more modern residential block. The original building, of which the early photograph shows the dance hall, was a rather austere brick building that had been financed by the Admiralty. Designed by George E. Bond, a noted architect of Rochester, it was to have stretched the entire length of Upper Barrier Road, but a planned west wing was never constructed. It was opened in February 1902 and provided both overnight accommodation and club facilities.

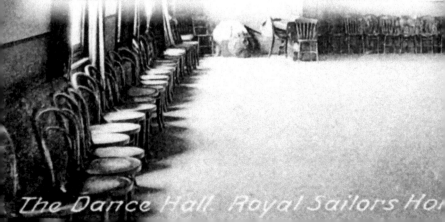

The Dance Hall, Royal Sailors' Ho[me]

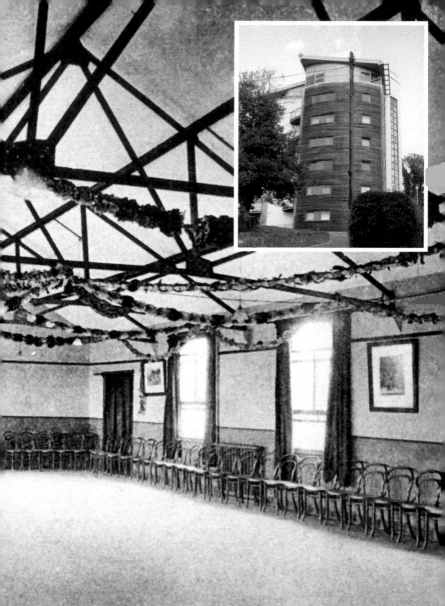

Chatham.

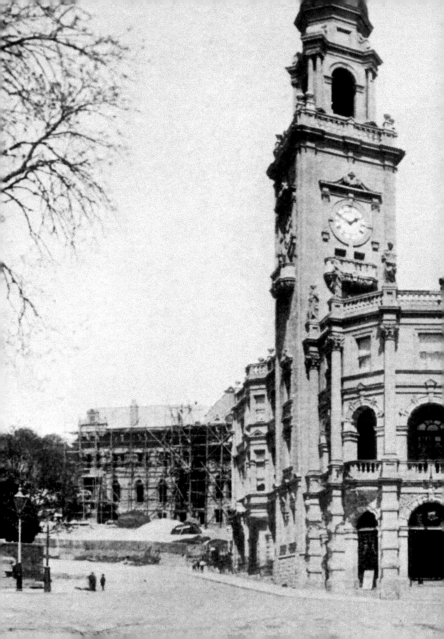

18. THE TOWN HALL

Also designed by George E. Best of Rochester, the town hall had its foundation stone laid in February 1898 and was completed some thirty-two months later. At that time the building was adequate for the administrative needs of the town while also offering space for dances and other ceremonial occasions. With the change of local government structure introduced in 1974, the town hall became less valued as a centre of administration and now has a more significant community role. The early photograph can be fairly precisely dated as having been taken in 1900. Supporting this conclusion is the building to the left, the Royal Sailors' Home, which is under construction; it was not to be completed until February 1902.

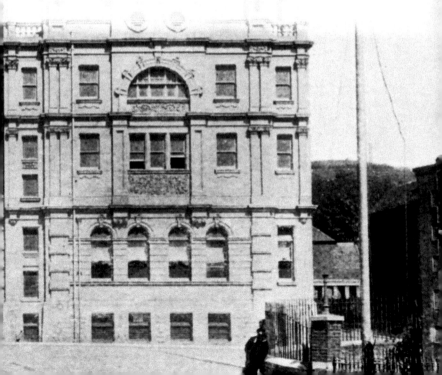

19. TRAMS AND BUSES

The tram interchange in Chatham was outside the town hall, with this example of a Chatham & District Light Railway car about to move off in the direction of Luton. It was only with the introduction of the Pentagon that an enclosed area for public road transport was introduced into Chatham. However, the Pentagon bus station, from its inception, drew many complaints due to a build-up of fumes. A new area for buses, Chatham Waterfront Bus Station, has now replaced the one in the Pentagon.

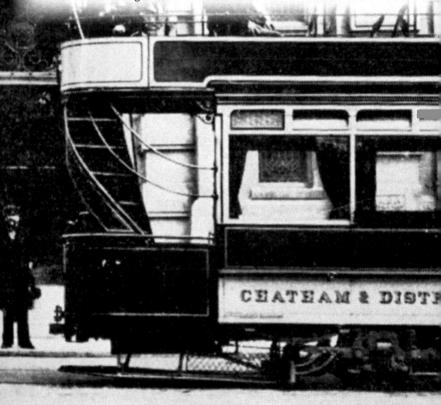

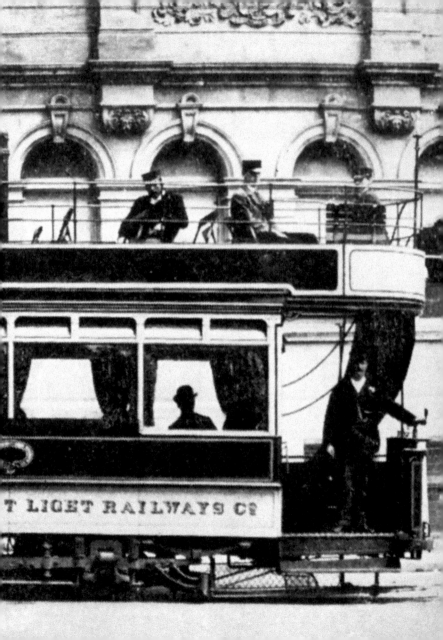

20. ROYAL MARINE SCHOOL

Situated near Chatham Waterfront Bus Station, the Royal Marine School building, constructed during the late nineteenth century, now serves as an Armed Forces Careers Office.

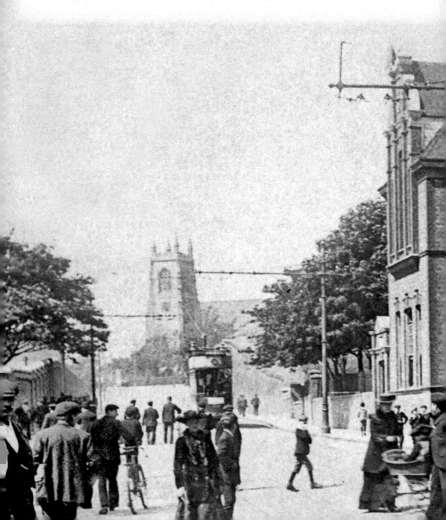

21. THE PADDOCK

An area of grassland adjoining Military Road, the Paddock, is rarely given the priority it deserves. Whenever a new road-building project is undertaken, the Paddock is either chopped about or reshaped. This is also the situation with the current regeneration programme, with the Paddock having to be reduced for the new and once highly controversial Waterside bus station.

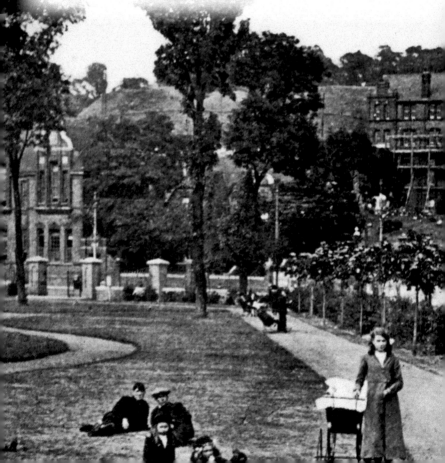

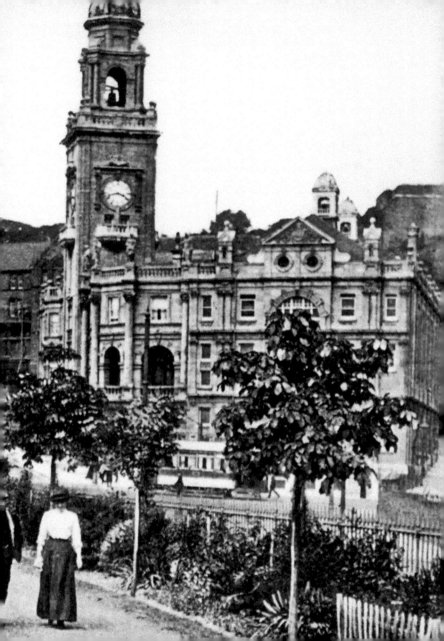

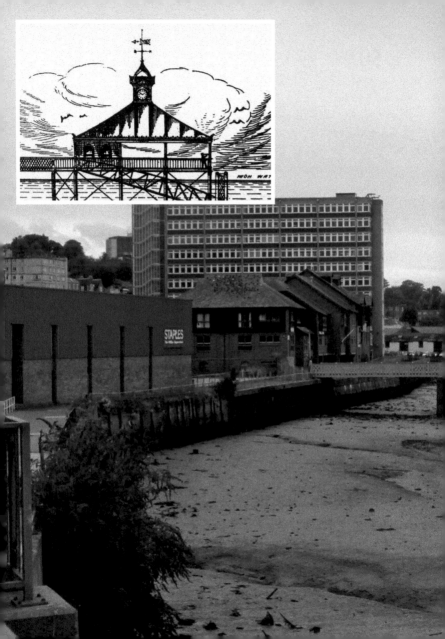

22. SUN PIER

In the summer of 1885, Chatham narrowly avoided a terrible tragedy when part of the publicly owned Sun Pier collapsed, throwing more than eighty people into the Medway. Dozens of people had to fight for their lives but no one was drowned or seriously injured. The cause was the collapse of a temporary walkway that stretched 80 feet out to allow passengers to join pleasure steamers that traded between Southend, Upnor and Sheerness. This and a general history of the pier actually go unmarked on the structure. Some sort of orientation board would certainly add something to a fairly featureless structure that (as discovered by the cameras of BBC South) offer unrivalled views of Chatham and the river that has made the town what it has become.

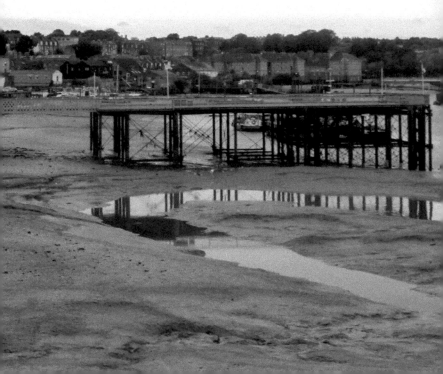

23. RIVERSIDE

The opening out of the river frontage has become a significant asset to Chatham, creating an area with outstanding views that is only a brief walk from the town centre. Much of this land was once part of the ordnance wharf while beyond the Medway Gunwharf building is the Historic Dockyard.

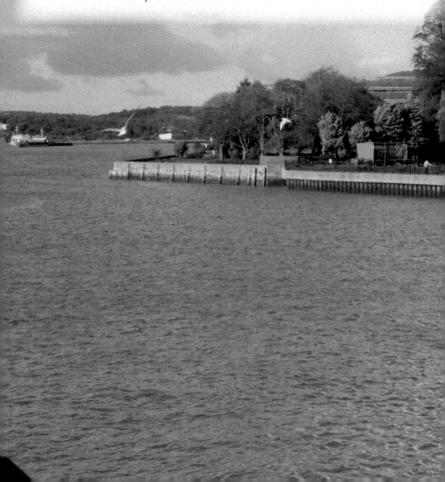

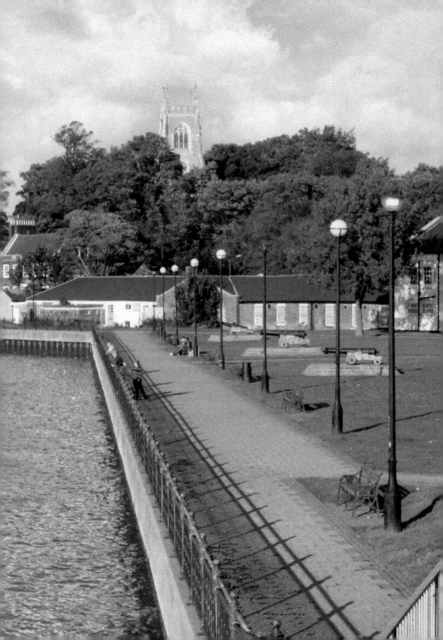

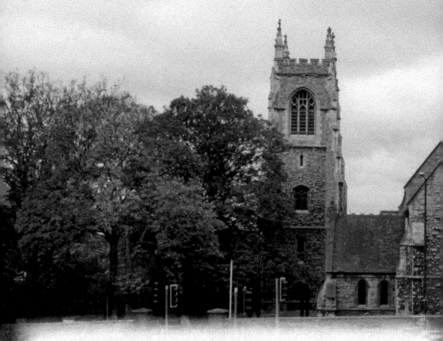

24. ST MARY'S CHURCH

The original parish church of the town, St Mary's was declared redundant by the Church Commissioners in 1974 and shortly after became a heritage centre. More recently it has returned to its religious base, now as a Redeemed Christian Church of God. As a building it has undergone numerous alterations that have taken it from a medieval Gothic-style building through to a complete refashioning in the classical style, followed by a return to its current mock-Gothic exterior. Opposite the church building is an equestrian statue of Lord Kitchener in dress uniform (Grade II-listed), which was placed here in 1959 following its removal from Khartoum.

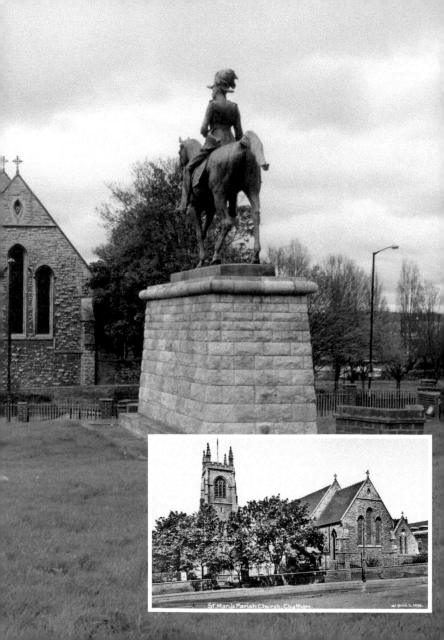

St Marys Parish Church, Chatham.

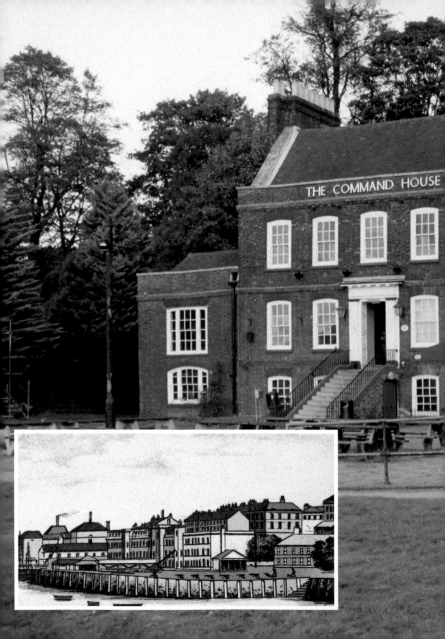

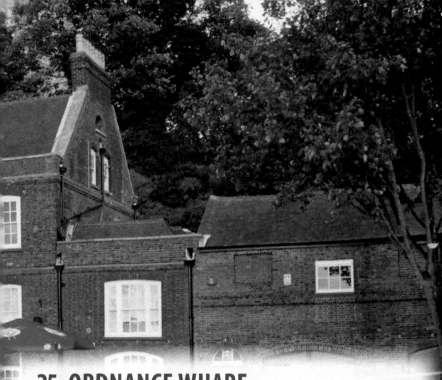

25. ORDNANCE WHARF

The Ordnance, or Gun Wharf, stood alongside the River Medway and had, at its most southerly point, the area now known as Riverside Gardens. It was here that naval guns were stored and maintained. Originally it was not a naval establishment, being administered by the War Office through the Ordnance Board. Established during the early part of the sixteenth century, the Chatham Ordnance Wharf first occupied the site of the original Tudor dockyard. The earlier picture shows the Ordnance Wharf as it appeared in the mid to late nineteenth century. The modern-day photograph is of the Command House, a building that once formed part of the Wharf when it served as the house of the Deputy Armament Supply Officer. It is also visible in the earlier picture.

26. CHATHAM BARRACKS

Originally constructed as an infantry barracks that accommodated soldiers manning the Chatham Lines, Chatham Barracks (later renamed Kitchener Barracks) was originally constructed in 1757. Only a very few of the earlier buildings remain. Within this early view, which dates to the end of the reign of Queen Victoria, it is possible to appreciate how some of the earlier barrack blocks appeared at the time of original construction.

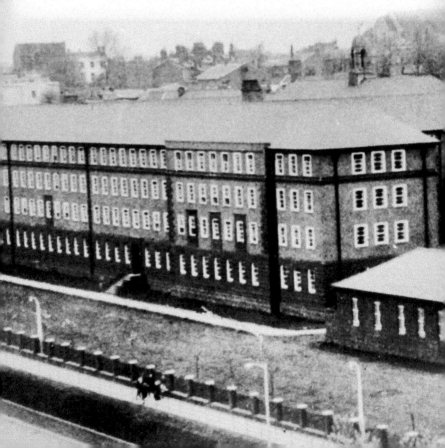

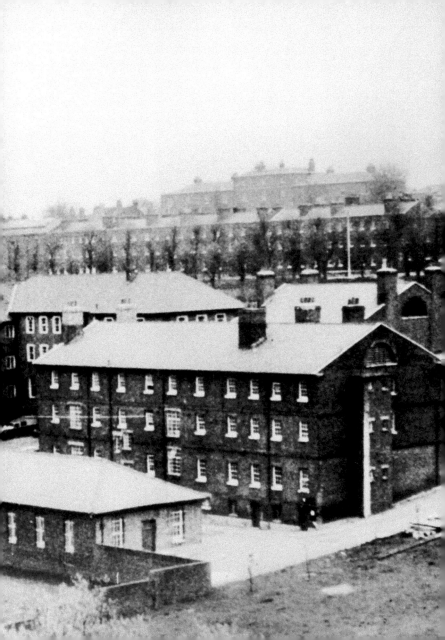

27. ROYAL MARINE BARRACKS

The Royal Marine Barracks, built sometime around 1779, was closed in 1950 and demolished a few years later. Located midway along Dock Road, it is now the site of the Medway Council administrative buildings. Unfortunately, despite being on the site of the old Royal Marine Barracks and a distance from the Gun Wharf, the building is emblazoned with the words 'Medway Council Gun Wharf'.

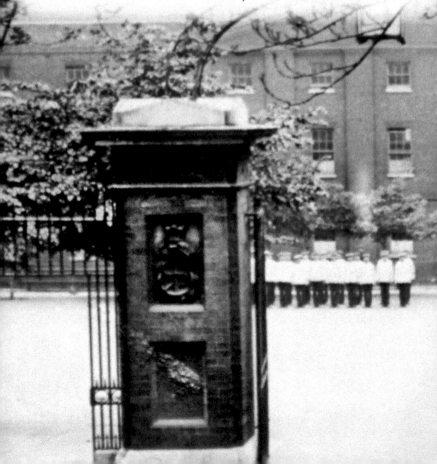

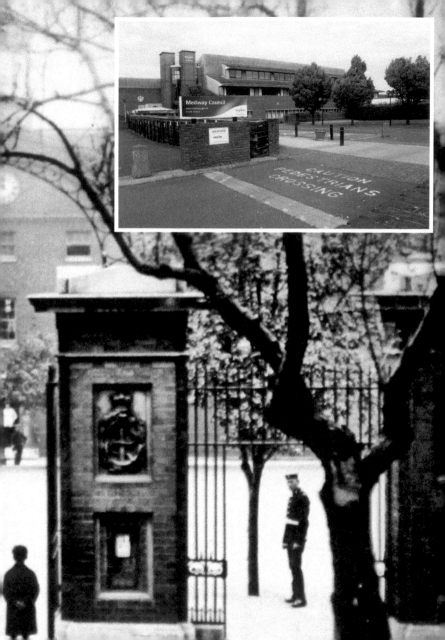

28. SOLDIERS' INSTITUTE AND GARRISON CLUB

Forming part of the boundary to Chatham Barracks, but not constructed until 1861, was the Soldiers' Institute and Garrison Club. Designed to meet the off-duty needs of those serving in the barracks, it was the forerunner of a number of military social clubs that were built in Chatham towards the end of the century. Among facilities available were smoking and coffee rooms, a bar, library and bowling club while a lecture theatre was added in 1872. The building itself no longer exists but its location, alongside Dock Road, is easily found – the original entrance portico lies embedded into the wall that encircles the barracks.

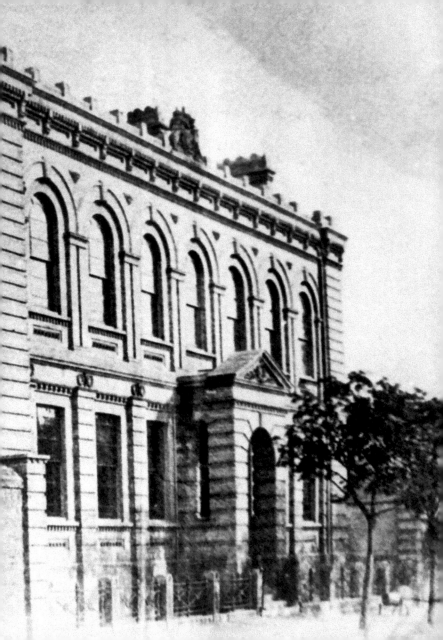

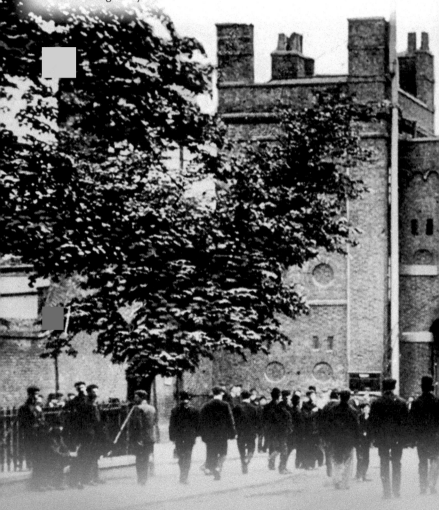

29. THE DOCKYARD

The main gate to the dockyard is shown at the beginning of the twentieth century. On this occasion, the workers are entering rather than leaving the yard.

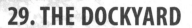

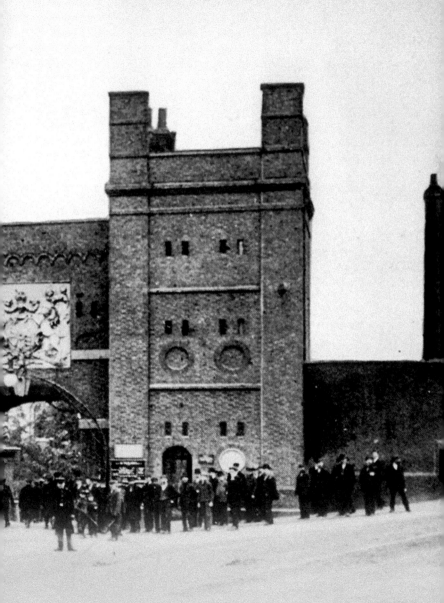

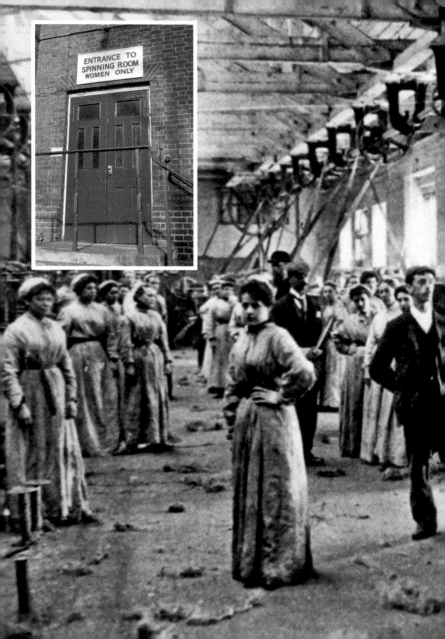

ENTRANCE TO
SPINNING ROOM
WOMEN ONLY

30. SPINNING FLOOR

Although women worked in most areas of the dockyard during the two world wars, this proved, up until the later years of the twentieth century, a fairly exceptional occurrence. Instead, the employment of women had been mainly restricted to the spinning room of the ropery and the colour loft. This had been allowed from the mid-nineteenth century onwards, with the Admiralty imposing a number of strict rules that included women having a separate entrance when working alongside men and having hours of work that permitted them to enter and leave the yard at different times to that of men. Here, women are seen employed on the spinning floor of the ropery in 1902 while the sign designating their separate entrance point has been restored and returned to its original location.

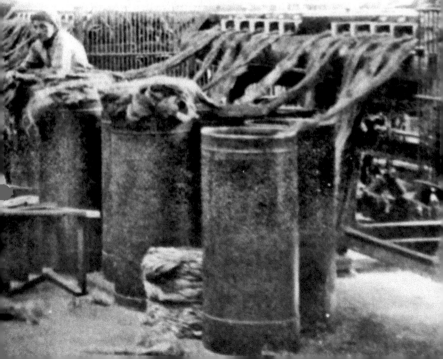

31. HMS *GANNET*

The 'Dotterel' class sloop HMS *Gannet* was originally launched at Sheerness dockyard in August 1878 and went on to serve in the Pacific, Mediterranean and Red Sea. Briefly, also, she served at Chatham as a harbour service vessel before (and under the new name of *President*) eventually being sold out of service and becoming a training ship. In 1987 she eventually returned to the Medway and began a lengthy period of restoration at the dockyard. In these two pictures, a comparison can be made between how she appeared on her first arrival and how she now appears with her restoration complete.

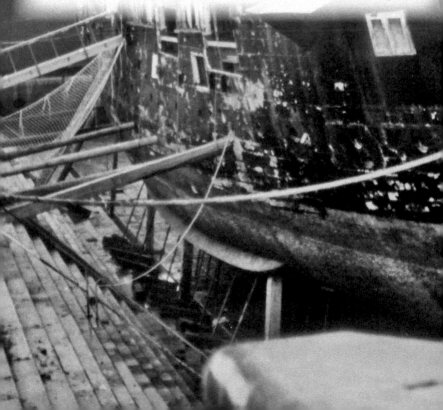

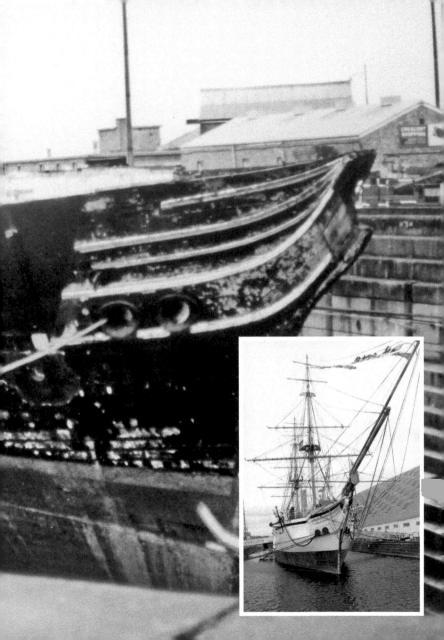

32. DOCKS AND SLIPS

One of the most impressive features of the Historic Dockyard at Chatham is its collection of docks and covered slips. In this early twentieth-century photograph, the destroyer *Greyhound* is undergoing repairs in Dock No. 4, with the photographer also providing a partial glimpse of No. 3 Slip. It was either on open slips or under a covered slipway that ships were built and launched. Little has changed in this area of the yard other than it is *Gannet* that now occupies No. 4 Dock. Of the various slip covers still to be found in the dockyard, No. 3 is the earliest, roofed over in 1838. Three nearby slips were given cast-iron covers in 1847–48 while a further slip was covered in 1855.

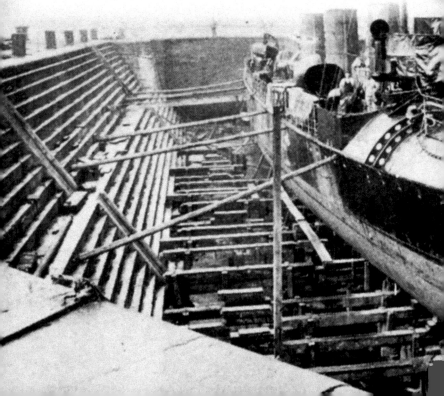

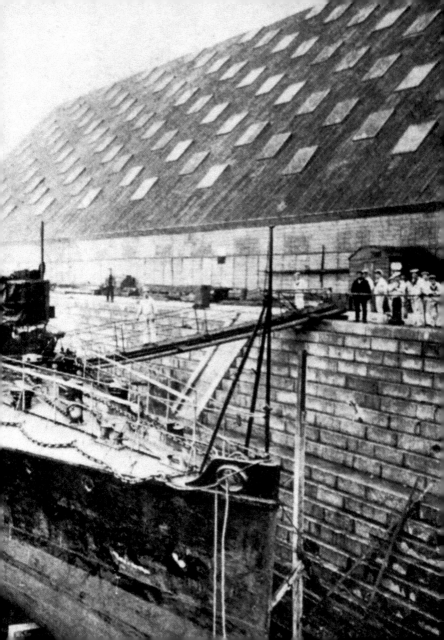

33. HMS *OCELOT*

Ocelot was the last submarine built at Chatham for the Royal Navy, although three other similar submarines were built in the dockyard for the Royal Canadian Navy. Launched in 1963, she was returned to Chatham in 1991 (seen in the earlier photograph on her arrival on that occasion) when she was paid off prior to her being prepared as a visitor attraction.

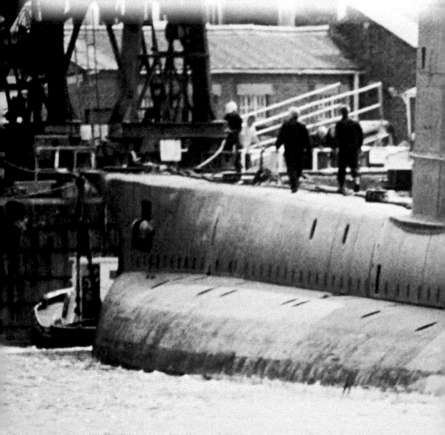

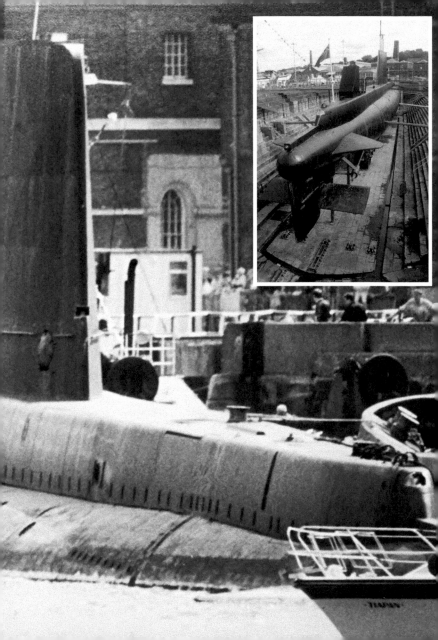

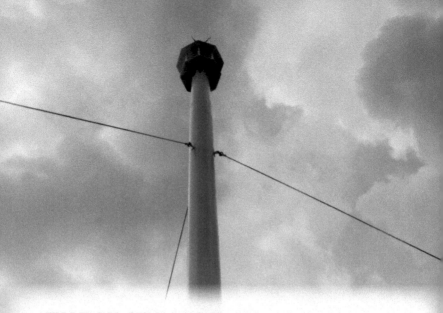

THE VICTORIAN DOCKYARD

The third walk begins at the bell mast. This is an appropriate and easily located starting point for a tour of the Victorian extension to the dockyard. It was the bell of this mast that summoned the workforce at the start of each working day. Information boards are positioned around the base of the mast and from its sheltered cover the impressive collection of rooves over the slips in the older part of the yard can be viewed together with a mast pond and the entrance to the Royal Navy barracks.

34. THE BELL MAST

A Grade II-listed building, the bell mast began life as the foremast to *Undaunted*, and was installed as a dockyard muster bell in 1903. It originally stood further to the east and was erected on its present site in 2001.

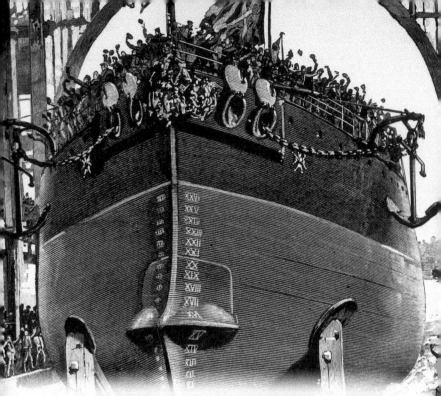

35. HMS *RODNEY*

To be viewed from the site of the Bell Mast are covered slips referred to earlier (*see* No. 32), with this picture showing the inside of No. 7 Slip and the launch of *Rodney*. The 'Admiral' class battleship HMS *Rodney* was launched at Chatham dockyard on 8 October 1884 and was commissioned in the Medway nearly four years later. Built beneath the coverings that were placed over a number of the building slips of the yard, these roof structures had to have sufficient height to provide sufficient space for the building of the massive hulls of these warships. Nowadays the building slips remain, although their use has altered quite significantly.

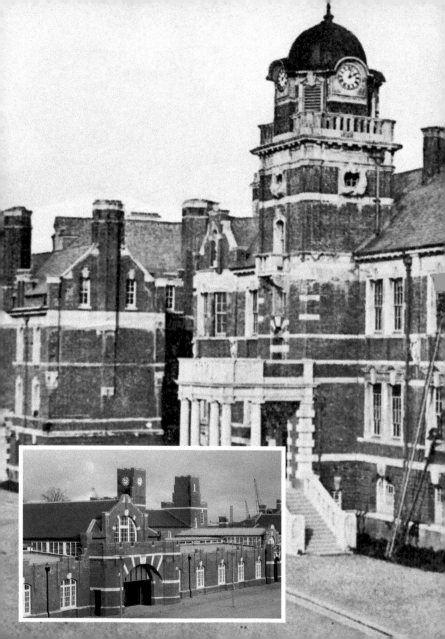

36. ROYAL NAVAL BARRACKS

The naval barracks at Chatham, named HMS Pembroke, were completed in 1903. For those in training or awaiting a transfer to a new ship, the barracks were a marked improvement upon the old hulked warships of the Medway that had previously served this purpose. The earlier photograph shows part of the barracks shortly after completion while the old parade ground is to be seen in the modern-day photograph inset.

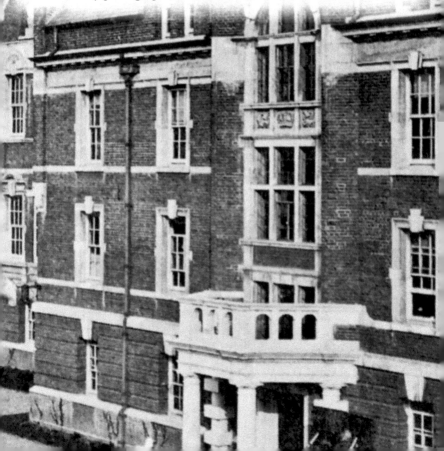

37. SHIP FITTERS' SHOP

The much-vaunted Dickens World, which closed in October 2016, stood on the approximate site of a once important industrial building, the Ship Fitters' Shop. Those who once worked within the building were responsible for work carried out on the auxiliary machinery of warships, including steering gear, winches, windlasses, valves and rudders. That Dickens World should be brought to the area of the former dockyard built on the link that the famous novelist had with the yard, as his father was employed at Chatham Dockyard as a pay clerk.

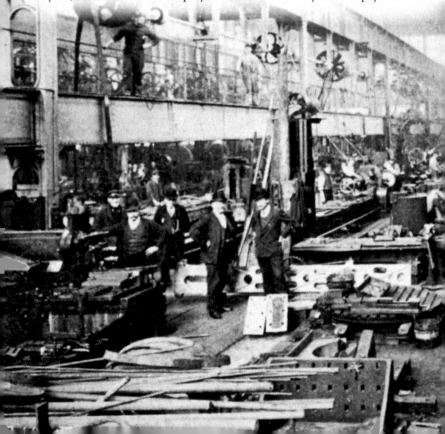

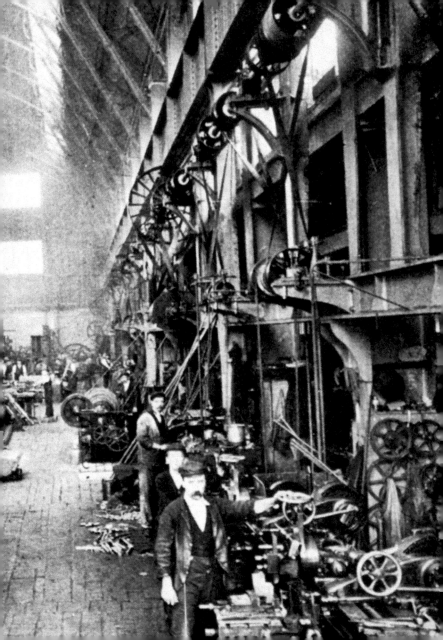

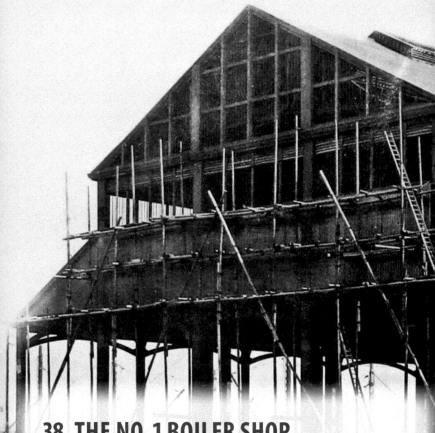

38. THE NO. 1 BOILER SHOP

The No. 1 Boiler Shop (aka Chatham Outlet) under erection sometime around 1875 and following its arrival from Woolwich. Now better known for its use as a shopping mall, this building began life in Woolwich dockyard and, following the closure of that yard in 1869, was disassembled and brought to Chatham, where it was shortly after re-erected on its present site.

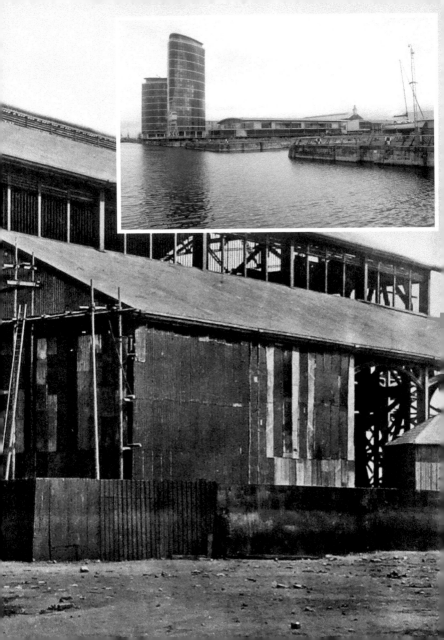

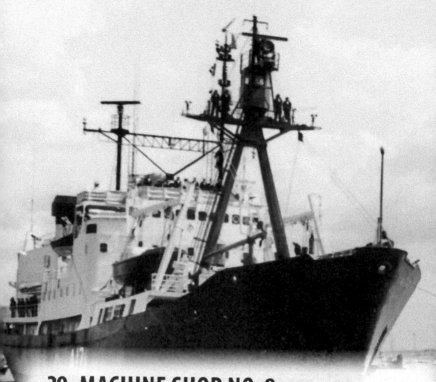

39. MACHINE SHOP NO. 8

Situated alongside the former No. 8 Dock, the Machine Shop (inset) was a further building brought to the yard from Woolwich, re-erected at Chatham in 1875. Although originally clad in corrugated sheeting, this suffered substantial storm damage in October 1987 and had to be removed with only the frame of the building retained. It is now a Grade II-listed building. Following her return from the Falklands in 1982, HMS *Endurance* (seen here on her return to Chatham on that occasion), a survey ship that played a vital role in the conflict with Argentina, was immediately placed into the No. 8 Dock, where some of the work undertaken upon her was carried out by those employed in the No. 8 Machine Shop.

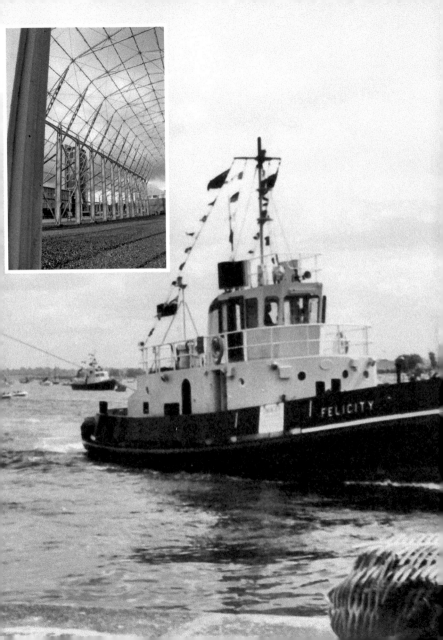

40. NO. 7 DOCK

Just over 426 feet in length, the No. 7 Dock was one of four docks built on the south side of the Repairing Basin. Built by convicts, such as those depicted, who may well have worked on this very dock, it is still an important feature of the dockyard. It is overlooked by residential flats today.

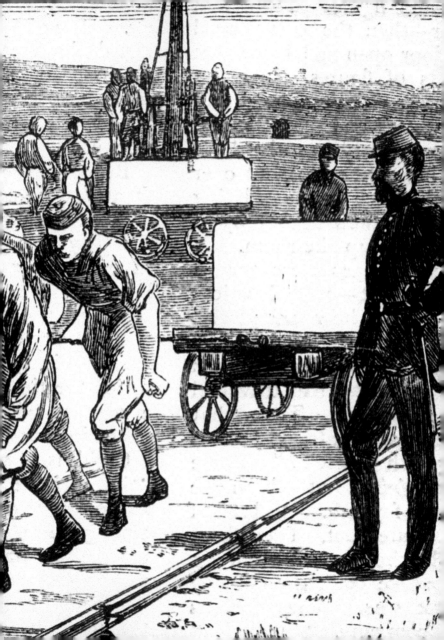

41. DOCKSIDE

By 1871 (*see* page 88) the Repairing Basin and its three docks was substantially complete, although caissons (floating dock gates) are still needed for the two nearest docks (Nos 5 and 6). One building that was eventually to be positioned on the vacant land to the south is that of Boiler Shop No. 1.

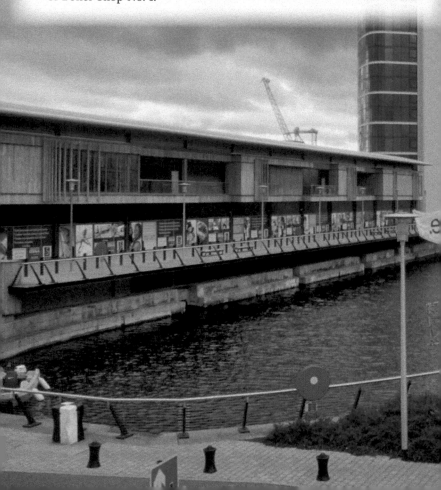

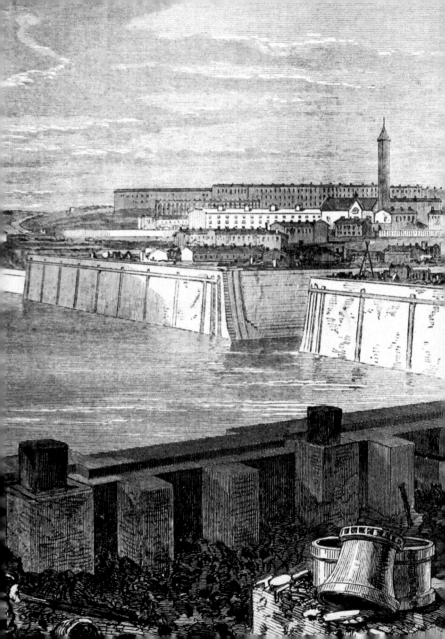

42. THE REPAIRING BASIN

Planned in 1865 and under construction by 1868, the Repairing (or No. 1) Basin was just over 20 acres in size and was part of a massive 300-acre extension to the existing yard. Beyond the building works, and where the Navy Barracks was subsequently built, can be seen the convict prison that supplied much of the workforce. The modern view of the Repairing Basin shows that a few of the original buildings have been retained.

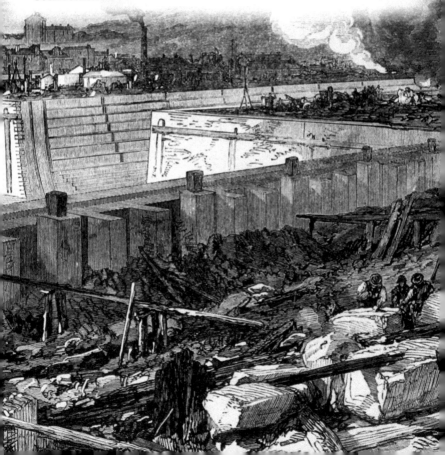

43. THE DISTANT NO. 3 BASIN

A feat of imagination is now needed. No. 3 Basin lies much further to the east and beyond the No. 2 Basin. However, it is part of an industrial zone with restricted entry. It is possible to get a glimpse of this former area of the yard but only from the outside. A particular refit specialism that Chatham dockyard performed during the Cold War was on Leander-class frigates. Here *Scylla* is seen in Basin No. 3.

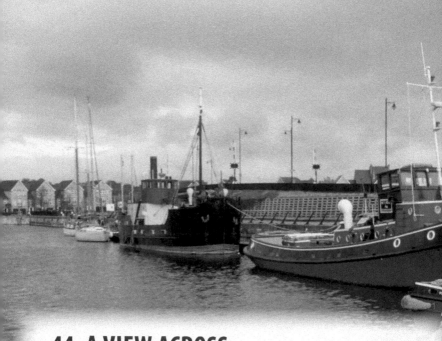

44. A VIEW ACROSS
THE REPAIRING BASIN

At one time the basins of the dockyard played an important role in the repair and maintenance of warships. In all, there were three basins built during the late nineteenth century, respectively known as the Fitting-Out Basin (the most easterly and largest), the Factory Basin (situated in the middle) and the Repairing Basin. Most commonly, maritime craft to be found in the Repairing Basin are usually pleasure craft, although a small collection of historic vessels (owned by the South Eastern Tug Society) is also held in the basin.

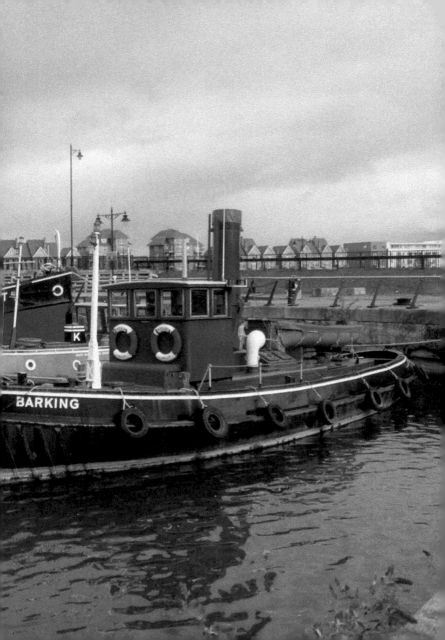